The
MIXED MEDIA POCKET PALETTE

Practical visual advice on
how to create over 250
mixed media combinations

Ian Sidaway

NORTH LIGHT BOOKS
Cincinnati, Ohio

A QUARTO BOOK

Copyright © 1996 Quarto Inc.

First published in the U.S.A. by
North Light Books, an imprint of
F & W Publications, Inc.
1507 Dana Avenue,
Cincinnati, Ohio 45207
(800) 289-0963.

ISBN 0-89134-756-9

This book was designed and
produced by
Quarto Publishing plc
The Old Brewery
6 Blundell Street
London N7 9BH

Designer Sally Bond
Copy editor Maggi McCormick
Senior editor Sally MacEachern
Picture researcher Miriam Hyman
Editorial director Mark Dartford
Art director Moira Clinch

Typeset by Central Southern
Typesetters, Eastbourne
Manufactured in Singapore by
Bright Arts Pte Ltd
Printed in China by Leefung-Asco
Printers Ltd

CONTENTS

HOW TO USE THIS BOOK

This book is designed to be an at-a-glance guide to over 250 mixed media effects. Some combinations such as pastel and watercolor are tried and tested, others such as oil, sawdust, and ink are much more experimental. Mixing mediums can add surface sparkle and interest to a painting and is an exciting way for an artist to broaden his or her mastery of materials and mediums. Experimentation is essential (possible combinations are not always immediately obvious) to arrive at a combination that is suitable for a particular situation. The combinations shown here should be used as a springboard for further experiments. The only restriction is stability: will the combination of materials chosen last or will they deteriorate over time?

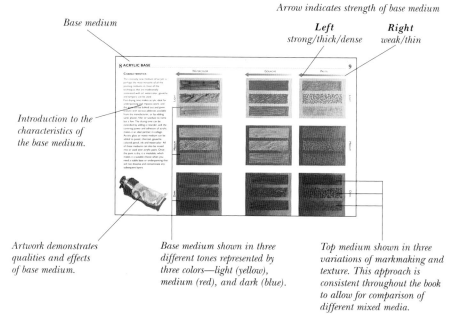

Arrow indicates strength of base medium

Base medium

Left
strong/thick/dense

Right
weak/thin

Introduction to the characteristics of the base medium.

Artwork demonstrates qualities and effects of base medium.

Base medium shown in three different tones represented by three colors—light (yellow), medium (red), and dark (blue).

Top medium shown in three variations of markmaking and texture. This approach is consistent throughout the book to allow for comparison of different mixed media.

The first spread of each base medium introduces its characteristics (as shown above). This spread and the following spread demonstrate the effects of adding specific top mediums using different brushstrokes. The final variations spread demonstrates the effects of more experimental media mixing.

4 **TECHNIQUES**

All of the traditional techniques that are normally associated with the various artist's mediums can be used in mixed media work. The artist only has to be aware of one medium's compatibility with another. This normally means not working over the top of a dry, oil-based medium with watercolor, gouache, or acrylic and not mixing a water-based and oil-based medium into each other. It pays to organize your work space efficiently; it becomes only too easy in creative mid-flow to reach for a tube of oil paint when you are working with acrylic, or dip a brush loaded with watercolor into a jar of turpentine.

There are two primary considerations or techniques that should be borne in mind when using mixed media. Both involve the sequence of application – whether a wet medium remains soluble when dry, and, if the medium being worked over is a dry medium, whether or not it has been fixed.

FIXED & NON-SOLUBLE UNFIXED & SOLUBLE

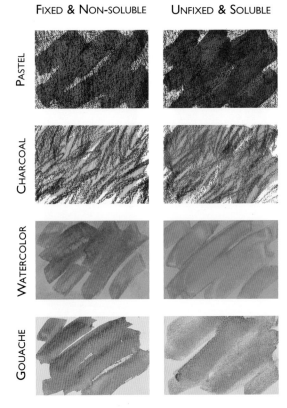

PASTEL

CHARCOAL

WATERCOLOR

GOUACHE

These swatches show how working one medium (in this case acrylic) over another produces different effects, depending on whether the layer being worked on is stable or not. The pastel and charcoal swatches are fixed and unfixed, while watercolor and gouache swatches are mixed first with gum arabic to increase their solubility when dry and then with acrylic medium, which has the effect of making them insoluble when dry. The acrylic overpainting can be seen to lie over the fixed, or insoluble, swatches without dissolving or mixing with them, while the unfixed or soluble swatches are all modified by the acrylic paint mixing with them.

Many effects depend on the layering of different mediums for their success. Color is affected in one of two ways. As already described, if the layer of color being worked on is unfixed or soluble, it will mix to a greater or lesser extent with any subsequent color that is applied. If, however, the underlayer is stable, then any subsequent layer of color will remain pure. If the top color is applied thinly as a transparent glaze, the undercolor will show through, mixing optically but not physically. This technique of glazing is well proven and is regularly used in traditional oil, acrylic, watercolor, and tempera work because of the resonance and inner light the technique brings to the work. But it also allows colors to be combined and mixed in layers to give colors completely different from those mixed wet into wet.

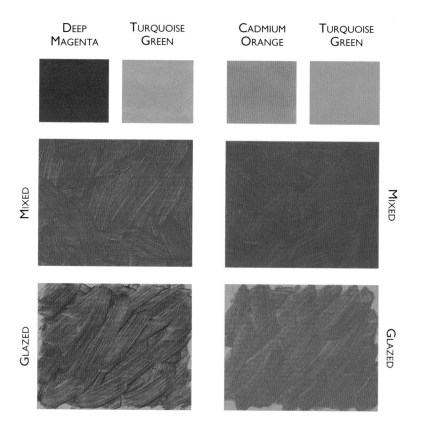

Here Deep Magenta and Cadmium Orange are mixed with Turquoise Green. When the same two colors are glazed over Turquoise Green, as seen here, they give a completely different effect and color.

MARK MAKING

Marks are the artist's vocabulary and the richer your store, the more you will be able to express yourself. Push your materials to the limit, while being aware of their limitations. The marks shown below can all be made with heavy or light pressure and applied sparsely or densely. When these factors are combined with the nature of each medium you can achieve great variety of tone and texture.

POINT MEDIA STICK MEDIA BRUSH MEDIA

LIGHT COVERAGE

STIPPLED DASHES
Colored Pencil

DASHES
Graphite stick

STIPPLING
Watercolor

MEDIUM COVERAGE

HATCHING
Ball point pen

HATCHING WITH POINT
Soft pastel

LONG DASHES
Ink

CROSS HATCHING
Fine liner

CROSS HATCHING
Conté pastel

THICK STIPPLING
Oil

HEAVY COVERAGE

RANDOM DASHES
Ink

**RANDOM STROKES:
USING SIDE OF STICK**
Charcoal

**DENSE/SHORT
BRUSH STROKES**
Acrylic

LIGHT COVERAGE

MEDIUM COVERAGE

HEAVY COVERAGE

The characteristics of a medium can be extended and altered by making use of the many painting mediums and additives available from art stores. These substances work in a number of ways, are often usable with several different mediums, and are necessary to exploit and realize a medium's full potential. A few of the more common ones are listed below, together with a brief description of their use and characteristics.

ACRYLIC MEDIUMS

There are so many acrylic mediums that they are grouped together here. Each has very distinct characteristics. Manufacturers produce freely available information on their products which helps explain their full potential. Retarding mediums extend the usual quick drying time of acrylic paints; gel mediums also extend drying time while increasing the body, brilliance, and transparency of the paint. These gel mediums can be used for thick impasto effects, as can acrylic extender, which economically increases the paint's volume. Matte mediums impart a flat, matte finish to the paint, while gloss mediums give a sheen to the work and are often used as a final varnish. Mixed half and half with water, gloss medium can also be used as a fixative and applied through an atomizer or spray. Texture pastes give both body and texture to the paint. All acrylic mediums can be mixed with watercolor and gouache, and the matte and gloss mediums mix well with dry mediums like charcoal, water-soluble colored pencil and pastel. All acrylic mediums are insoluble once they dry.

AQUAPASTO

Aquapasto is a transparent gel medium that can be mixed with watercolor and gouache to give body. This makes impasto effects possible.

GLAZING MEDIUM

Like turpentine and mineral spirits, glazing medium can be mixed with pastels.

GUM ARABIC

Gum arabic and its thinner version, gum water, remain soluble when wet and intensify color. Traditionally an additive for watercolor painting, it can be mixed with any water-based mediums, and can be mixed with water and worked into pastel, charcoal and other dry mediums. Used thickly, it gives a glossy sheen to the work, but if used too thickly, it can crack and pull away from the support.

LIQUIN

Liquin is an additive for oil paint that improves the flow and transparency of oil colors. It also reduces drying time, often making it possible in the right conditions to overwork a few hours later.

OLEOPASTO

Oleopasto is a stiff gel that is added to oil paint to give body and to extend the paint, making it go farther. It is used to build up thick impasto areas of paint.

TURPENTINE

Turpentine and mineral spirits are the two thinners commonly used for oil paint. They cannot be mixed with water-based mediums such as gouache or acrylic, but can be put to good use by mixing with dry mediums like soft pastel or oil pastel. Remember you can use solvent or oil-based mediums over the top of water-based mediums but not vice versa.

While manufacturers go to great lengths to make sure materials are safe, some mediums and additives can be an irritant or harmful if they are used in an unusual way. Always read manufacturers' warning notes and labels, and take special care not to breathe in dust or pigments, especially when spraying.

Aquapasto, Liquin and Oleopasto are Winsor & Newton products and trademarks of Colart, Fine Art & Graphics Ltd.

8 ACRYLIC BASE

CHARACTERISTICS

The relatively new medium of acrylic is perhaps the most versatile of all the painting mediums as most of the techniques that are traditionally associated with oil, watercolor, gouache and tempera can be used.

Fast drying time makes acrylic ideal for underpainting and impasto work, and the paint can be bulked out and given texture with various additives available from the manufacturer, or by adding sand, plaster, filler or sawdust to name but a few. The drying time can be extended by adding a retarder, and the covering power and adhesion of acrylic makes it an ideal partner in collage. Acrylic gloss or matte medium can be added to pastel, charcoal, gouache, colored pencil, ink and watercolor. All of these mediums can also be mixed into or used over acrylic paint. Once the paint is dry, it is insoluble, which makes it a suitable choice when you need a stable base or underpainting that will not dissolve and contaminate any subsequent layers.

WATERCOLOR

LIGHT

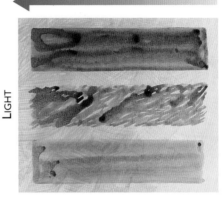

MEDIUM

DARK

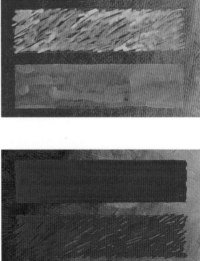

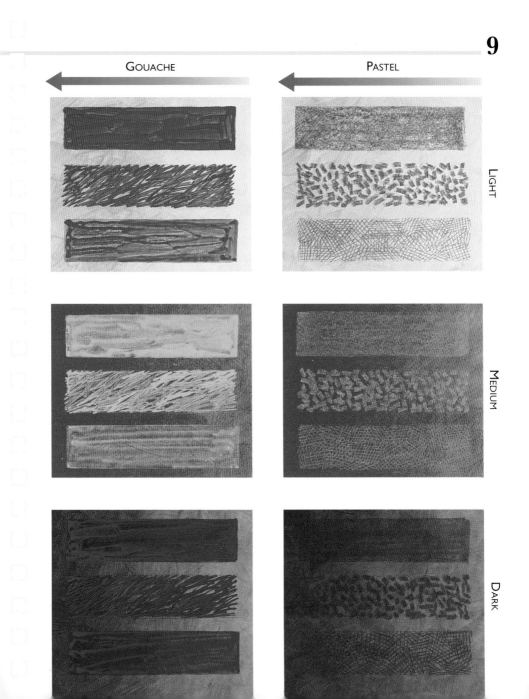

GOUACHE
PASTEL

LIGHT

MEDIUM

DARK

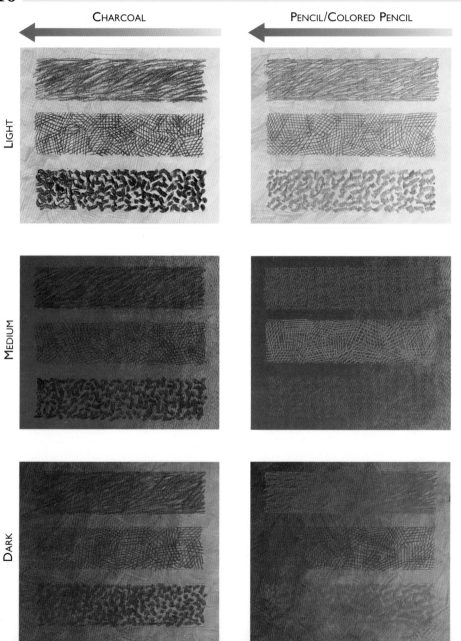

CHARCOAL

PENCIL/COLORED PENCIL

LIGHT

MEDIUM

DARK

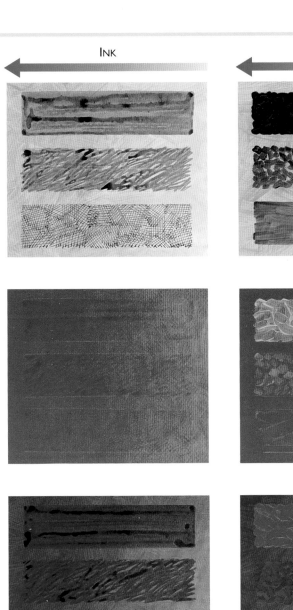
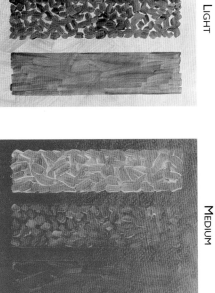

INK OIL

LIGHT

MEDIUM

DARK

12 ACRYLIC BASE VARIATIONS

Acrylic paint mixed with sand texture paste,
allowed to dry, then overworked with soft pastel.

Acrylic paint mixed with sand texture paste,
allowed to dry, then overworked with oil paint.

Acrylic paint mixed with sawdust, allowed to dry,
then overworked with ink.

Acrylic paint allowed to dry, then overworked
with oil pastel.

Soft pastel worked into acrylic paint thinned with
matte medium.

Charcoal worked into acrylic paint, allowed to
dry, then overworked with more charcoal.

Acrylic paint allowed to dry, then overworked with charcoal.

Acrylic paint allowed to dry, then overworked with soft pastel.

Dry acrylic paint overworked with colored pencil, then with matte medium.

Dry acrylic paint overworked with ink, allowed to dry, then overworked with oil paint.

Dry acrylic overworked with spattered ink.

Dry acrylic overworked with gouache, allowed to dry, then overlaid with ink.

Zinary Sherster

This bright decorative work has been made on canvas. Layers of acrylic modeling paste give texture and have been overworked with acrylic paint. The painting is finished using oil paint glazes that give depth and vibrancy (which can be difficult to achieve by other means) to the colors.

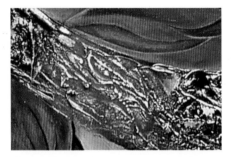

▲ *Acrylic modeling or texture paste is applied using a palette knife. Similar effects can be achieved using spackling (decorating filler) or plaster mixed with acrylic medium and water; if a coarser texture is desired, use sand or sawdust.*

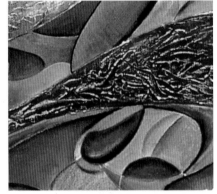

◀ *The design is worked initially with acrylic paint. Its quick drying action means the artist can overpaint, altering and adapting the design after only a few minutes.*

▲ *Once the acrylic is dry, areas of the painting are reworked using oil paint. Its longer drying time allows the artist to blend colors together, creating a peacock feather-like shimmer to the color. Oil paint can be glazed over the texture paste, creating color that appears deeper in the troughs or valleys, and thinner or lighter on any of the textured peaks.*

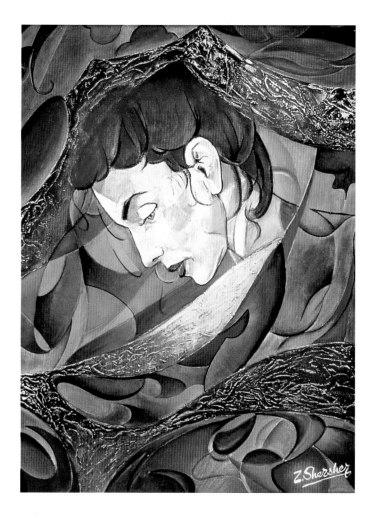

CHARACTERISTICS

Watercolor has a long tradition and is perhaps the most technique-led and difficult medium to master well. Many watercolor techniques are extremely subtle, and unlike some mediums depend to a large extent on the quality and texture of the support to achieve their effect. They are used mainly on paper, but can be worked to beautiful effect on gesso-primed board. Watercolors combine well with pastel, ink, gouache, acrylic, pencil and colored pencil, or any other dry drawing mediums. They tend to be applied mostly with brushes but can be sprayed or sponged on, as well as being applied to surprisingly good effect with a palette knife or a chisel-shaped piece of cardboard. Watercolors will not take over oil paint or greasy materials, but these mediums can be combined with watercolor for resist techniques.

GOUACHE

LIGHT

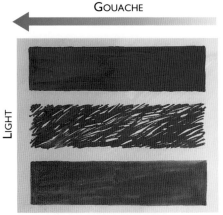

MEDIUM

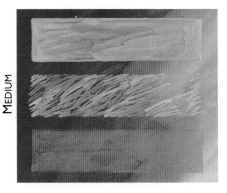

DARK

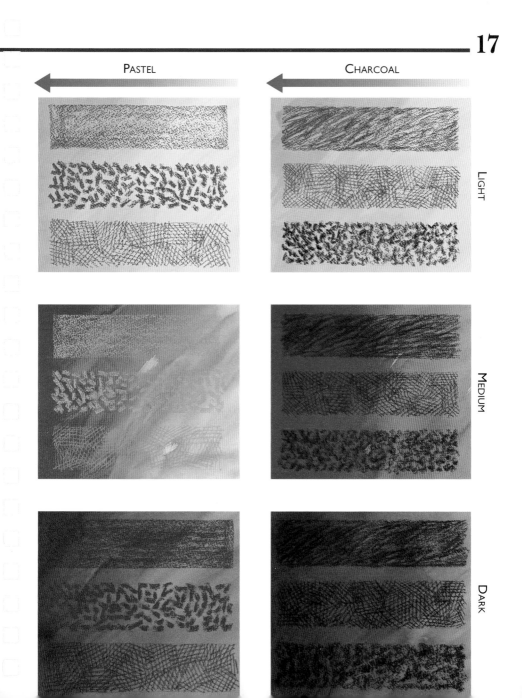

PENCIL/COLORED PENCIL

INK

LIGHT

MEDIUM

DARK

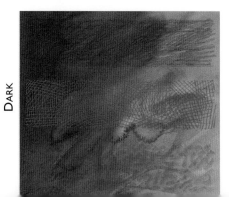

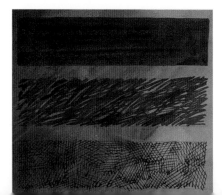

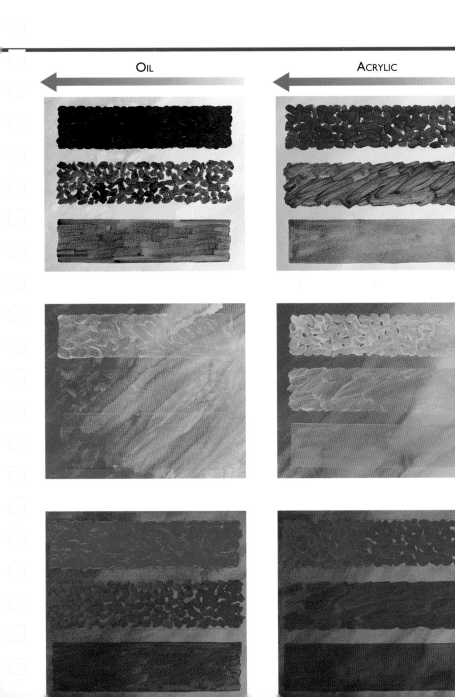

Acrylic paint mixed with texture paste over watercolor.

Impasto oil paint over watercolor.

Watercolor mixed with acrylic gel medium.

Watercolor mixed with aquapasto overlaid with ink.

Soft pastel worked into wet watercolor.

Charcoal worked into wet watercolor.

Soluble colored pencil worked into watercolor.

Ink dribbled into watercolor.

Watercolor brushed over acrylic texture paste.

Water-soluble ballpoint pen worked into watercolor.

Watercolor overworked with a paint marker.

Acrylic paint brushed into wet watercolor.

CHARACTERISTICS

Gouache shares many of the characteristics of watercolor, but it covers more readily because it is opaque. It remains extremely soluble when dry, so care should be taken in overworking with other liquid mediums. The paint takes readily to most ungreasy, oil-free surfaces and can be diluted to make thin, transparent washes or used thickly straight from the tube. Unlike watercolor, where colors are usually worked dark over light, the covering capacity of gouache makes it possible to lay bright, light colors over dark ones. The thick consistency of gouache makes it possible to produce a wide range of interesting textural effects using a variety of implements. Pastel, pencil, colored pencil, ink and especially charcoal take well onto dry gouache, and all of these drawing mediums can be worked easily into wet gouache. Adding acrylic mediums or gum arabic to the paint extends the possibilities still further.

PASTEL

LIGHT

MEDIUM

DARK

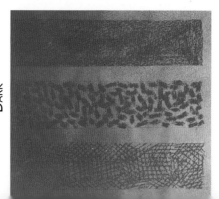

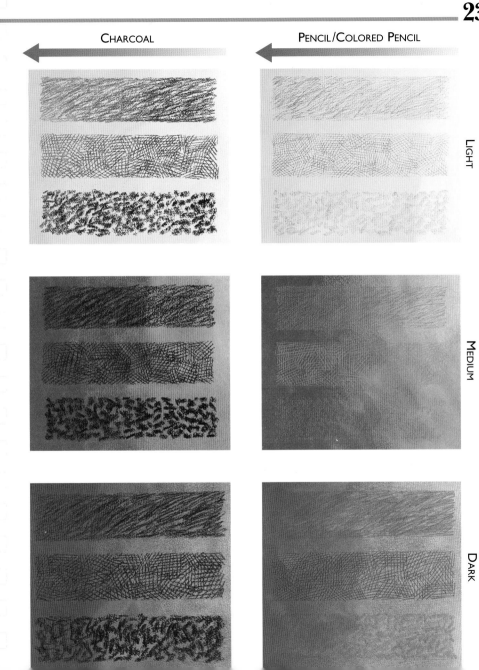

CHARCOAL

PENCIL/COLORED PENCIL

LIGHT

MEDIUM

DARK

INK

OIL

LIGHT

MEDIUM

DARK

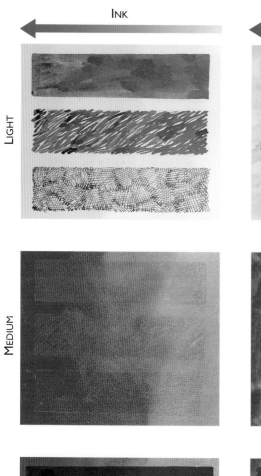

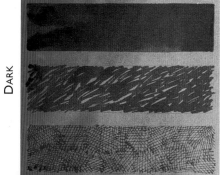

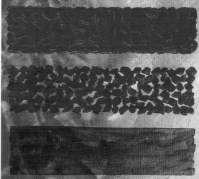

ACRYLIC WATERCOLOR

LIGHT

MEDIUM

DARK

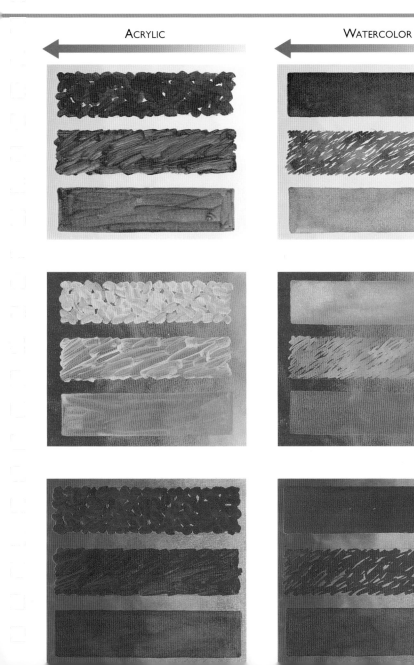

Gouache mixed with acrylic texture paste.

Gouache mixed with acrylic gloss medium.

Charcoal scribbled into wet gouache.

Ink brushed into wet gouache.

Gouache over acrylic texture paste.

Soft pastel worked into gouache.

India ink over dry gouache.

White glue dribbled on, allowed to dry, then overpainted with gouache.

Gouache allowed to dry and overpainted with oil mixed with Liquin.

Dry acrylic overpainted with acrylic mixed with heavy gloss medium.

Ink sponged over dry gouache.

Paint marker over dry gouache.

Jacquie Turner

Here, in an altogether looser approach using acrylic, collage, colored and graphite pencil, the artist has depicted the activities on a hot summer day at the beach. The picture is alive with the movement of the sea and colorful windbreaks flapping in the breeze. The loose yet considered application of paint suits the subject matter perfectly.

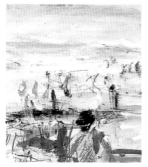

◄ *The underlying pencil drawing is allowed to show through, lending structure to the scene and acting as a guide and foundation for subsequent work.*

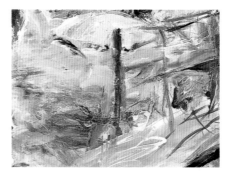

▲ *Loose impasto applications of acrylic paint mix and blend in an apparently haphazard manner suggestive of the sand and the jumble of colorful towels and clothes.*

▲ *Colored tissue paper is collaged onto the picture, adding extra surface interest and dimension. Acrylic medium or white craft glue can be used on most oil- and grease-free surfaces.*

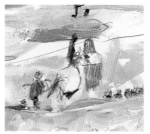

◄ *Colored pencil and graphite pencil are reintroduced to sharpen up and redefine selected areas.*

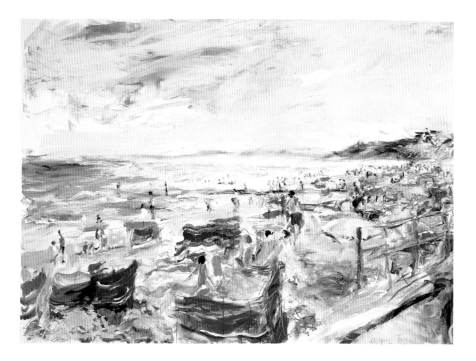

CHARACTERISTICS

Hard and soft pastels will take to most surfaces that have a texture or tooth, including paper, board, canvas and wood. They can be used over watercolor and gouache, ink, charcoal, pencil and colored pencil. All of these mediums can in turn be used over pastel, but thick accumulations of pastel need to be fixed to avoid being smeared or smudged. Because pastels consist of a high amount of pure, dry pigment, they can be worked into wet paint, either water-based or oil. Alternatively, the pastel itself can be worked into using water, an acrylic medium, mineral spirits and turpentine thinners or oil painting mediums and varnish. Once pastel is fixed, it can be worked over without fear of smudging or losing its distinctive grainy quality. Oil and wax pastels repel water, so they can create interest and texture using resist techniques. The color from both of these pastels will dissolve in oil-painting thinners and mediums, and can be worked to good effect into thin, wet oil paint.

CHARCOAL

LIGHT

MEDIUM

DARK

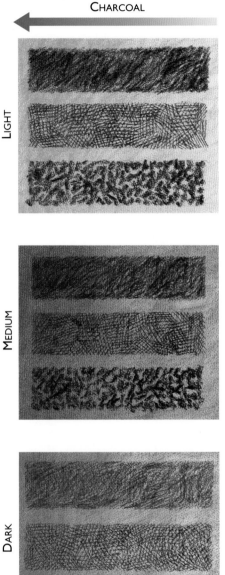

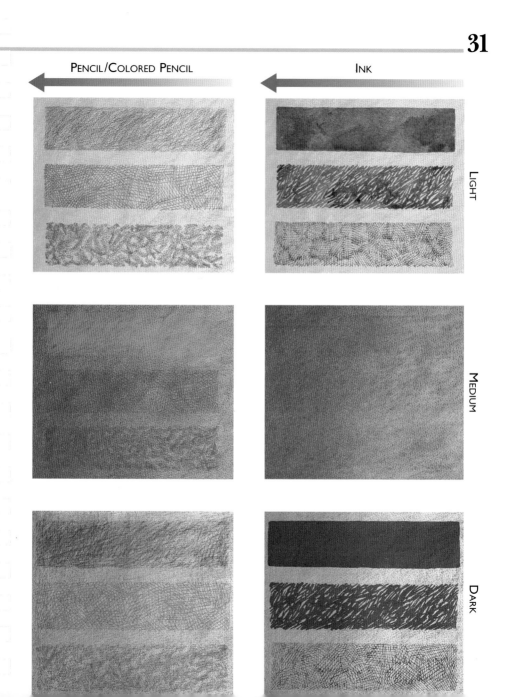

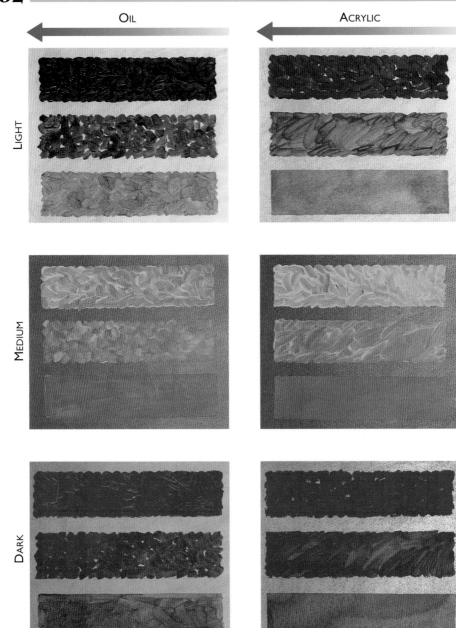

33

WATERCOLOR

GOUACHE

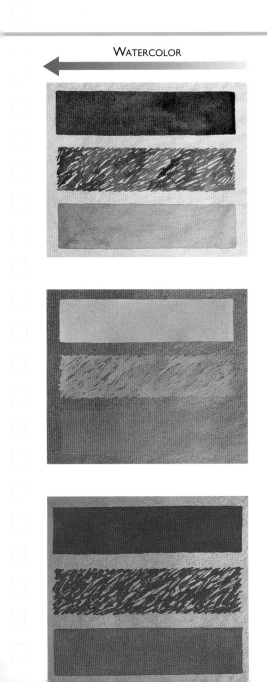

LIGHT

MEDIUM

DARK

Thin oil paint overlaid with soft pastel.

Thick acrylic paint dribbled onto soft pastel.

Oil pastel overworked with watercolor.

Oil pastel overworked with thin acrylic paint.

Oil pastel overworked with gouache.

Oil pastel overworked with ink.

Soft pastel overworked with graphite pencil.

Soft pastel overworked with ink.

Soft pastel overworked with heavy charcoal.

Soft pastel overworked with watercolor.

Soft pastel overworked with thick gouache.

Oil pastel overworked with oil paint.

CHARACTERISTICS

Traditional charcoal is available in a choice of thickness and degrees of hardness, as well as in compressed sticks made from powdered charcoal and charcoal pencils. It will take easily over all drawing and painting materials and is capable of achieving a wide variety of marks. Like pastel, it needs to be fixed to guarantee its permanence. It can be worked into wet paint and, again like pastel, thinned and the tone brushed out using oil painting thinners or acrylic mediums. Working into the charcoal with a kneaded eraser can be an especially effective way of representing textures. Charcoal is a bold medium, so to make very light charcoal marks, use a long stick and hold it well away from the drawing end; applying too much pressure will make the stick shatter.

LIGHT

MEDIUM

DARK

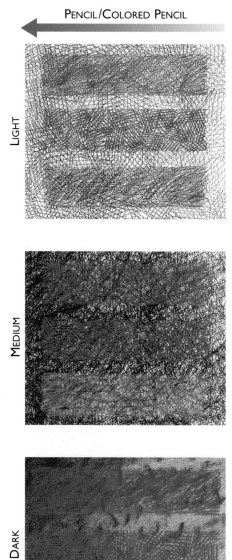

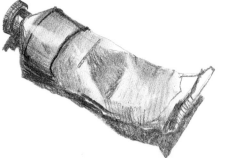

INK

OIL

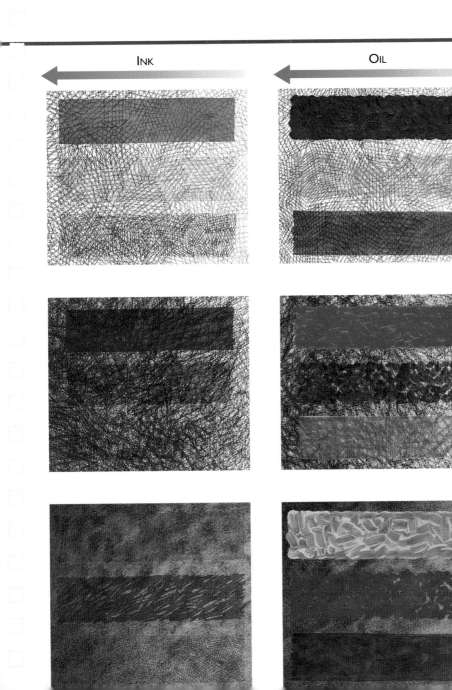

LIGHT

MEDIUM

DARK

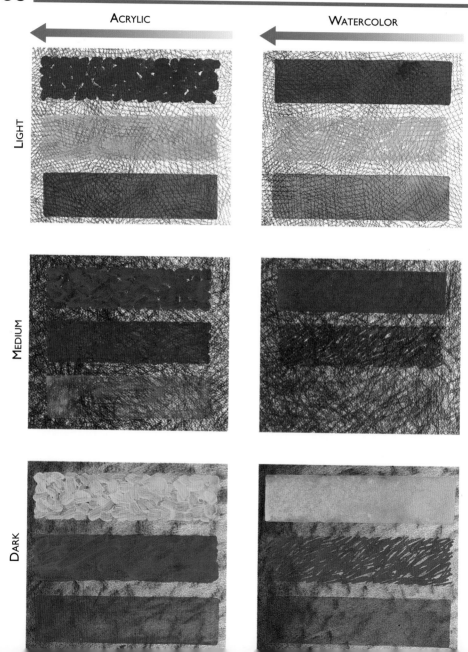

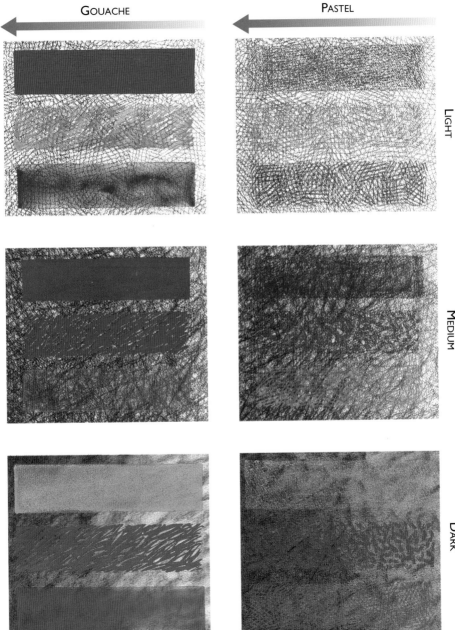

Gouache over fixed compressed charcoal.

Gouache over unfixed stick charcoal.

Watercolor mixed with watercolor medium over unfixed charcoal.

Latex paint over unfixed charcoal.

Pastel over watercolor over unfixed charcoal.

Paint marker over fixed charcoal.

Oil pastel and glazing medium over fixed charcoal.

Oil paint mixed with oleopasto over unfixed charcoal.

Acrylic paint mixed with heavy gel medium over unfixed charcoal.

Dribbled ink over fixed charcoal.

Sanguine conté and white chalk over fixed charcoal.

Spray paint over fixed charcoal.

CHARACTERISTICS

The traditional pencil is available in 20 grades of hardness, is straightforward to use and capable of producing a wide range of marks. Studio or sketching pencils have a flat graphite strip, and come in soft, medium and hard grades. The graphite stick, a solid pencil-shaped stick of coated graphite is probably the most versatile, easy-to-use pencil. Shorter, thicker, hexagonal-shaped uncoated sticks are also available. Both types have the advantage over traditional pencil in that not only can fine lines be made, but large areas of tone can be blocked in very quickly. Graphite is also available as a powder that is worked onto the support with the finger or a rag. Colored pencils in a large choice of colors are used in much the same way as graphite pencils; water-soluble pencils can be mixed with acrylic mediums, turpentine or mineral spirits. Both graphite and colored pencils take well over most mediums, but are especially effective combined with watercolor, gouache or pastel.

INK

LIGHT

MEDIUM

DARK

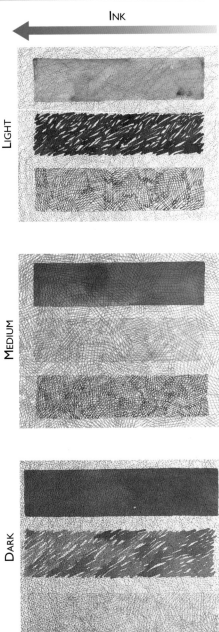

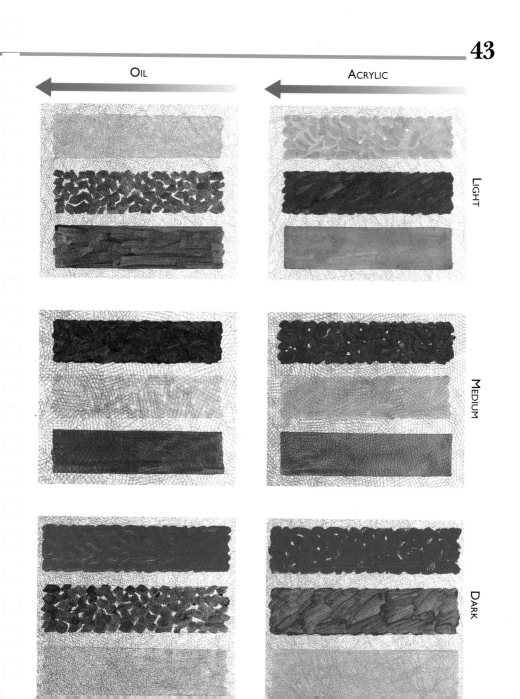

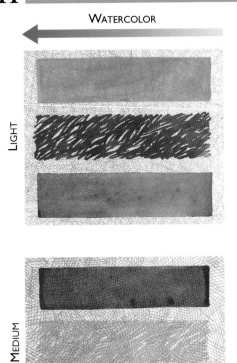

WATERCOLOR

GOUACHE

LIGHT

MEDIUM

DARK

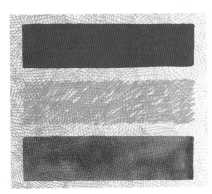

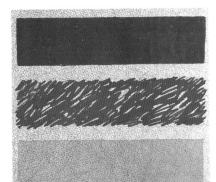

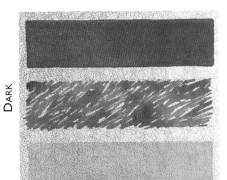

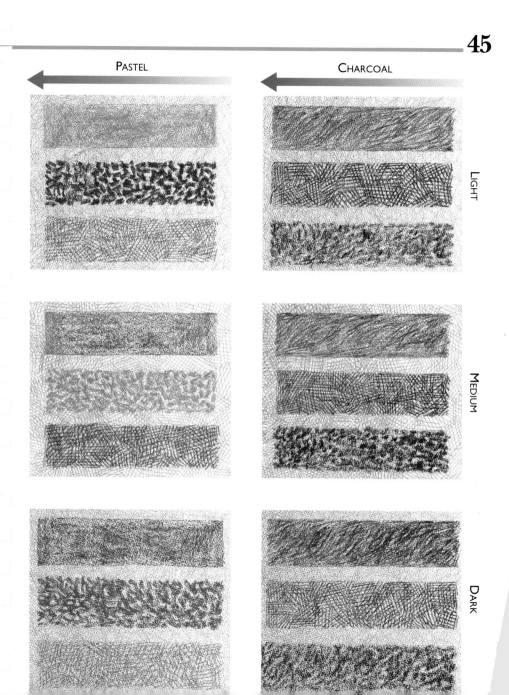

Gouache over graphite pencil.

Fingerprint ink blobs pressed into gouache.

Hatched ink over colored pencil.

Acrylic mixed with heavy gel medium over graphite powder.

Charcoal hatched over graphite powder.

India ink hatched over cross hatched colored pencil.

Watercolor over soluble pencil.

Solvent-based marker over pencil.

Oil pastel over pencil.

Acrylic medium into water-soluble colored pencil.

Oil paint mixed with Liquin over water-soluble colored pencil.

Soft pastel over graphite pencil.

Jane Hughes

Here the artist has cleverly used a controlled and carefully considered combination of various dry mediums, ink and collage to create the illusion of both three-dimensional objects and two-dimensional printed work torn or cut from magazines and books. The viewer has difficulty deciding which areas are collaged and which are drawn. In fact, except for the paper surfaces themselves, everything is drawn.

▶ *An ink fineliner delivers a controlled line of even thickness for the drawing of the garden plan. Again, this is done on paper that is carefully cut and pasted onto the main design, which appears to sit beneath the orange gardening gloves.*

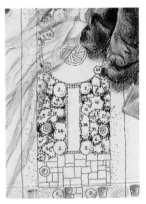

▲ *The drawing of the urn in brown, black, and white colored pencil has been done on a piece of buff paper which is then torn and carefully cut so that it appears to fit around and under other elements in the picture.*

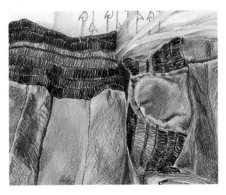

▶ *Heavy, layered colored pencil work is used to build up the color and tones seen on the well-used leather gloves. Sharp colored pencils are also used to make the lines that represent the elasticized stitching around the wrists.*

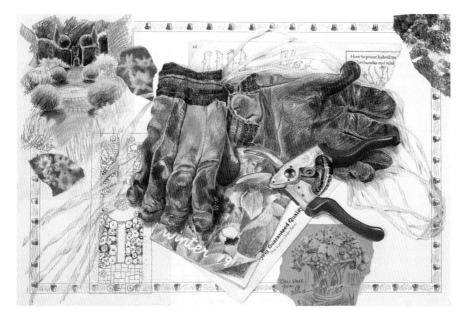

CHARACTERISTICS

Inks mix well with all drawing mediums, watercolor, gouache and acrylic paint. They can also be used for underdrawing or underpainting before working in oils. Applied with a pen or brush, or sprayed, the brilliance of the colors especially when combined with other mediums can result in some spectacular effects. Waterproof and permanent colored and black inks are available, and both characteristics can be put to good use when working various liquid mediums in layers. Inks can be used from a pen or brush as a drawing or linear medium, and they can also be diluted with water and used in much the same way as watercolor.

OIL

LIGHT

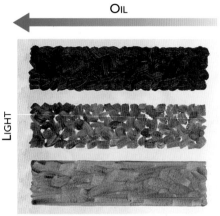

MEDIUM

DARK

ACRYLIC

WATERCOLOR

LIGHT

MEDIUM

DARK

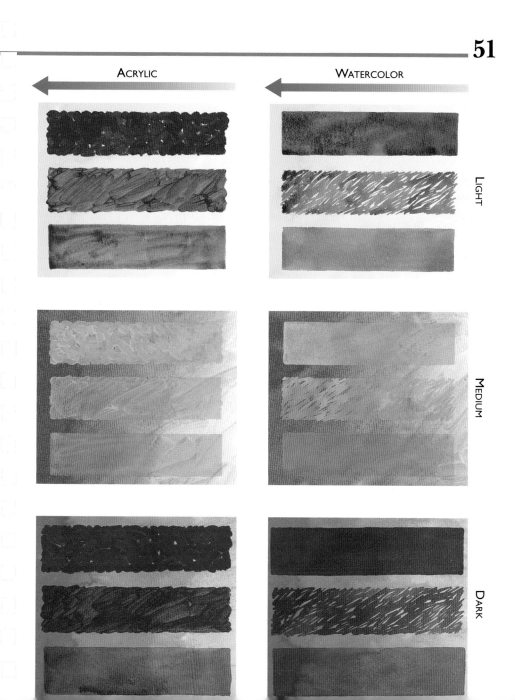

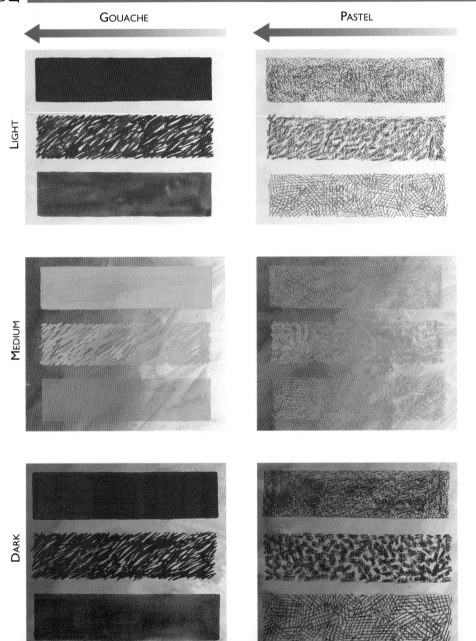

CHARCOAL

PENCIL/COLORED PENCIL

LIGHT

MEDIUM

DARK

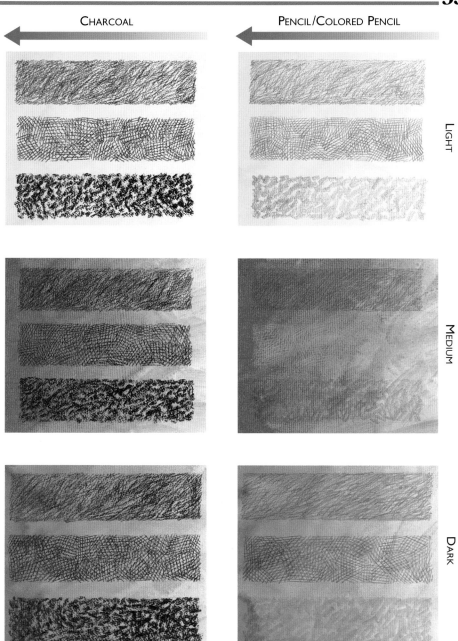

Ink mixed into acrylic texture paste.

Acrylic paint brushed into wet ink.

Oil pastel worked into wet ink.

Charcoal worked into wet ink.

Soft pastel worked into wet ink.

Ink over acrylic texture paste.

Oil paint glazed over India ink.

Impasto acrylic paint over ink.

Solvent-based marker over ink.

Watercolor mixed with gum arabic over ink.

Ballpoint pen hatched over ink.

Water-soluble colored pencil over ink.

CHARACTERISTICS

Oil paint has a long fine-art tradition that has been built on a number of tried and tested techniques. It can be used as thin as a watercolor wash to build subtle glazes, or as a heavy impasto. It will accept the addition of materials like sand and sawdust to add bulk and give texture; and as oil paint dries, there is no perceptible shift in color. Oil paint takes readily to most surfaces, and its long drying time can be cut considerably with the addition of a drier. Oil paint will not mix wet with water-based mediums, but can be worked over all drawing and painting mediums when they are dry. Drawing mediums such as charcoal, pastel, pencil, and to a certain extent ink, can be worked over oil paint once it is dry, while soft pastel, oil pastel, graphite and charcoal can be introduced into the paint while it is still wet. It should always be remembered that unlike all of the other painting and drawing mediums, oil paint will attack, and ultimately corrode, any support that is not protected with a suitable primer.

PASTEL

LIGHT

MEDIUM

DARK

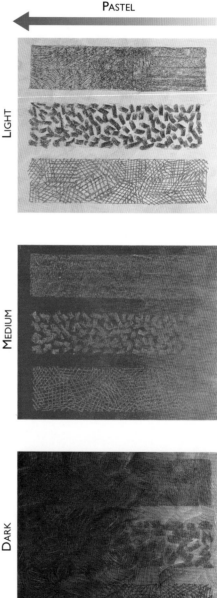

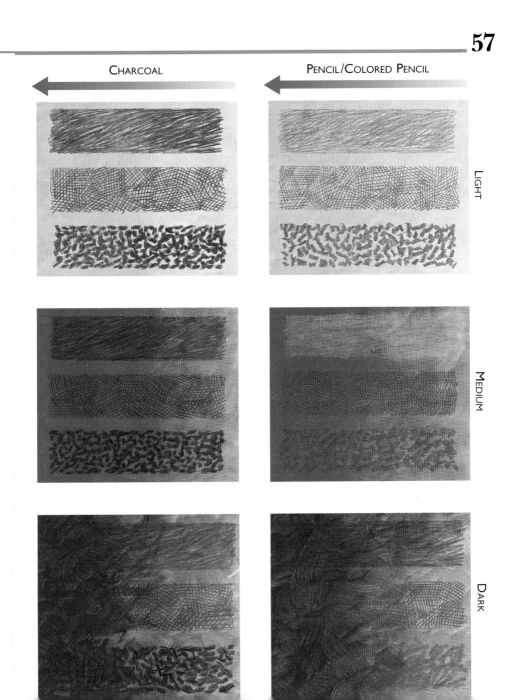

Oil paint and Oleopasto allowed to dry, then rubbed with graphite powder.

Oil paint and Oleopasto allowed to dry, then overpainted with ink.

Oil paint and Oleopasto allowed to dry, then overworked with spray paint.

Oil paint and Oleopasto allowed to dry, then overworked with soft pastel.

Oil paint mixed with silver sand and Liquin scratched through with a palette knife.

Oil paint mixed with silver sand and Liquin, allowed to dry, then overworked with charcoal.

Oil paint mixed with silver sand and Liquin, allowed to dry and overworked with ink.

Oil paint mixed with silver sand and Liquin.

Oil paint mixed with sawdust, allowed to dry, then overworked with ink.

Oil paint mixed with sawdust and Liquin.

Oil paint mixed with plaster, applied with a palette knife.

Oil paint mixed with Liquin and plaster, applied thinly.

Wax crayon mixed into oil paint thinned with turpentine.

Oil pastel mixed into oil paint thinned with turpentine.

Soft pastel mixed into oil paint thinned with turpentine.

Charcoal mixed into oil paint thinned with turpentine.

Oil paint allowed to dry, then overworked with oil pastel mixed with turpentine.

Oil paint allowed to dry, then overworked with soft pastel mixed with turpentine.

Oil paint allowed to dry, then overworked with wax crayon.

Oil paint allowed to dry, then overworked with graphite pencil.

Oil paint allowed to dry, then sponged over with gloss paint.

Soft pastel into oil paint thinned with turpentine, allowed to dry and overworked with more soft pastel.

Oil paint allowed to dry, then overworked with a correction marker.

Oil paint allowed to dry, then overworked with a paint marker.

Ian Sidaway

This picture was assembled in the studio from color notes and sketches made on the spot. It is painted using a variety of mediums, including acrylic and oil paint, graphite pencil and pastel. Sand and collage are also introduced to capture the subtle differences of texture and color which occur across the landscape. Mixing these mediums creates effects that serve not only to represent what was seen, but also as compositional devices that lead the eye around and through the picture.

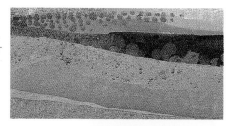

▶ *An area is first masked out using torn tape and paper and then overworked using soft purple pastel.*

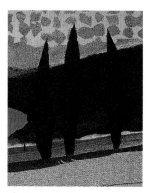

▼ *When sand is mixed into acrylic paint and the mixture is applied thickly, the light falling on the surface of the painting throws tiny shadows suggestive of a hillside covered in scrub and small bushes.*

▲ *The dark silhouettes of the Italian cypress were made by tearing out the rough shapes in masking tape to give a rough edge. They were then overpainted in oil. The strong dark color of the oil contrasts with the softer, blended background that has been worked using acrylic paint.*

▲ *Acrylic medium was used as an adhesive for sandpaper, coarse burlap, and torn paper, which have all been collaged across the center portion of the painting to represent the various textures of trees and crops in fields.*

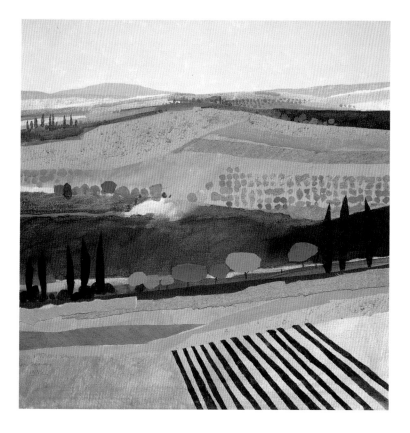

CREDITS

The publishers would like to thank
Daler-Rowney and Liquitex® for kindly
supplying materials for this book.

Aquapasto, Liquin and Oleopasto
are Winsor & Newton products
and are trademarks of
Colart, Fine Art & Graphics Ltd.